Lorenzo Monaco

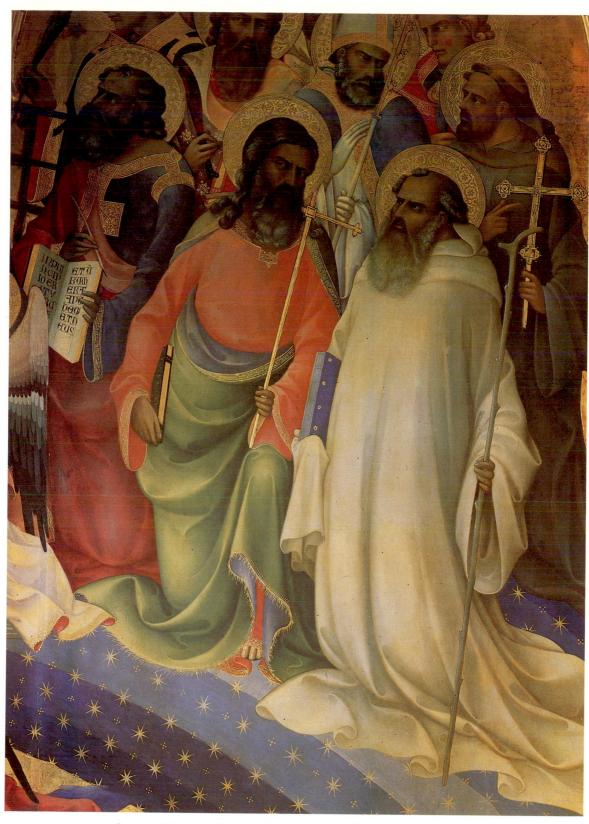

Lorenzo Monaco, Adoring Saints, detail of the Coronation of the Virgin, Uffizi, Florence.